THE
INTUITIVE
DRAWING
JOURNAL

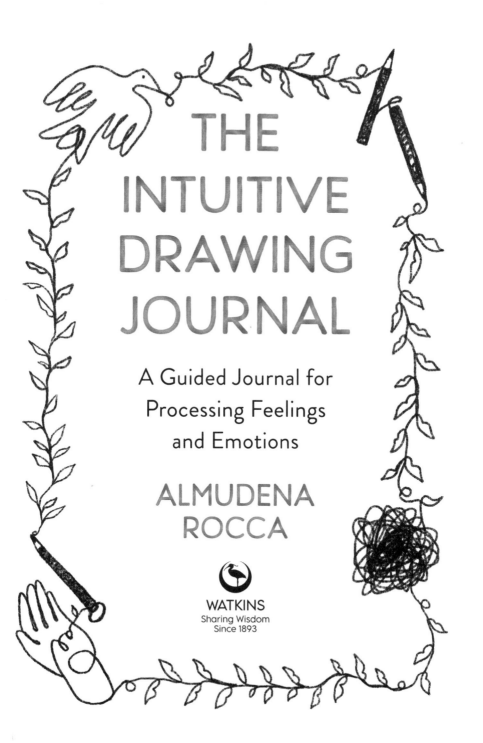

THE
INTUITIVE
DRAWING
JOURNAL

A Guided Journal for
Processing Feelings
and Emotions

ALMUDENA
ROCCA

WATKINS
Sharing Wisdom
Since 1893

The Intuitive Drawing Journal
Almudena Rocca

First published in the UK and USA in 2023 by
Watkins, an imprint of Watkins Media Limited
Unit 11, Shepperton House, 83–93 Shepperton Road
London N1 3DF

enquiries@watkinspublishing.com

Commissioning Editor: Lucy Carroll
Project Editor: Brittany Willis
Copyeditor: Sue Lascelles
Head of Design: Karen Smith
Designer: Steve Williamson
Production: Uzma Taj

A CIP record for this book is available from the British Library

ISBN: 978-1-78678-758-3 (Paperback)
ISBN: 978-1-78678-759-0 (eBook)

10 9 8 7 6 5 4 3 2 1

Printed in China

www.watkinspublishing.com

Important note: a gentle reminder that this book is not a
replacement for therapy with a qualified therapist, nor should
it be considered a form of therapy or art therapy. It describes a
therapeutic art process that may help relieve stress and anxiety.

This book is for you.

Allow yourself to be open and explorative. Give yourself permission to draw and then draw without judgement. And enjoy the process of being creative!

CONTENTS

INTRODUCTION

HELLO LOVELY READER,

My name is Almudena and I am an artist, tattooist and mental health advocate. I've written this book to help you express your emotions through a process called "intuitive drawing". Whether you are an experienced artist or just enjoy scribbling, this book will help you discover a whole new way of approaching a blank page. In particular, it contains lots of tools and ideas to help you unearth and release different feelings and emotions through art. It also offers a safe space in which to explore your emotions, however difficult they may be.

I'm interested in raising awareness around mental health, as I believe we still live in a world where this isn't always a priority. In the same way, I have always felt passionate about art. While drawing sits at the heart of my creative practice, as a multidisciplinary artist I work with a range of different mediums, including ceramics, screen printing and stained glass. When I create art, I really enjoy each step-by-step process that goes into making a finished piece, as each speciality takes time and patience and there are a lot of different steps to learn in between. My work – and this book – unites my interest in mental health awareness with my love of art by looking at the calming process of intuitive drawing.

Patience is something that I am continuously working on and something that I haven't always had a lot of! I've always been a very physical learner in that I enjoy working with my hands and seeing how things come together in a practical, visual way. Having never been particularly academic, I've found that I'm able to communicate my thoughts and feelings through art in a way I never could with words.

"TO AWAKEN
HUMAN EMOTION
IS THE HIGHEST
LEVEL OF ART."

ISADORA DUNCAN

Communicating creatively through art has also helped me heal deep wounds by bringing to light traumas and experiences that I hadn't properly processed. In fact, the inspiration for this book came a couple of years ago, after I experienced my first panic attack and severe anxiety, which set me on my own healing journey.

I went for counselling and my therapy sessions made me realize that I wanted to study counselling myself, which I went on to do. During the course of my studies, I learned so much about myself and other people that I decided to combine these insights with my knowledge of art to create an artistic process that can help us improve our mental health. As you will discover in this book, intuitive drawing can enable you to access your unconscious mind and release or work through any difficult, repressed emotions that may lurk there. If, like me, you are more of a visual thinker and you sometimes struggle to express what you feel in words, you could find intuitive drawing particularly freeing.

I also use this process in my work as a tattoo artist, where I enjoy interacting with my clients in ways that are empathetic, gentle and kind. Today, my clients and I frequently collaborate on creating a tattoo that feels healing for them, in an experience that combines mental health, wellbeing and art.

As you will see in these pages, my illustrations often tackle mental health stigmas, while also offering gentle reminders about the importance of self-care. I have always found that creating art that makes a statement – particularly one that is delivered softly, with empathy – is one of the best ways to connect with people and make them think and feel something new. You may, by now, have guessed that I enjoy working in spaces where improving mental health through creativity is the goal, and it's my privilege to share this with you.

WHAT IS INTUITIVE DRAWING?

My own therapist once told me that art can connect deeper than words, and this is something that I truly believe. Art can connect to the unconscious and help heal hidden wounds.

I remember experiencing this at university, when I often felt lost and unsure of why I was there. One day, as I sat on the train on my way home, worrying that I would probably have to drop out, I began to scribble. I started to draw without lifting the pen off the paper, which gave me a surprising sense of relief. In my doodle, I could see faces – and that's when I started drawing using the continuous line technique. There are many ways to use this drawing style to create art, and I go into detail about six of them later (see pages 22–33).

After I graduated, I thought a lot about this drawing style and how it can be used intuitively; and how beneficial this could be to those of us who find it hard to vocalize our emotions. It can be difficult for many of us to find the right words to express how we are feeling.

I decided to create *The Intuitive Drawing Journal* to enable other people to access this technique and use it to help them explore their feelings. A lot of people never allow themselves the space to explore art or any form of creativity because they think they can't draw or they're not creative, so I wanted to create a book to tackle that mindset by setting out a simple drawing method that uses mark-making.

HOW CAN INTUITIVE DRAWING HELP YOU?

Intuition is a gut feeling that connects you to your natural instincts. It is also about those sudden moments of inspiration and flashes of insight. Most importantly for our purposes, it's a way to get in touch with your inner being, which can then help you experience relief from stress and anxiety – particularly when you have powerful yet safe ways to express those emotions through a practice such as intuitive drawing.

Intuitive drawing can help you connect to your own creative intuition, which enables you to discover inspired and imaginative ideas without using a conscious thought process. It helps set the stage for creative freedom and being able to let go of whatever is holding you back. In some respects, you could almost say that it is an evolution of mindfulness, in that we don't have to focus consciously on being here in the now. Instead, we can connect with the present moment simply through the act of drawing itself.

While intuitive drawing isn't a type of art therapy as such, many forms of therapy do use art to help connect to the unconscious mind. The relationship between art and the unconscious goes back a long way. Most notably, perhaps, the surrealist artists of the early twentieth-century sought to connect with the unconscious mind through their work, and to unlock the power of the imagination. By remaining unbound by moral controls, surrealist artists created art based on actual living human thought processes.

In this respect, art can act like a mirror to the unconscious; and tapping into the unconscious mind can help us realize that we all have it within ourselves to heal and release our true potential, which in turn allows us

to have a better understanding of ourselves and all that we are capable of achieving. This is how, after an unpromising start at school, and with many challenges in my own path, I found my way to where I am today – by drawing without analytic thinking, unconsciously and intuitively.

HOW TO WORK WITH THIS BOOK

In this book, you will first be guided through some simple drawing techniques that use continuous line drawing. These will help you loosen up and get into the flow of mark-making and drawing, whether you have drawn before or not.

Then we will look at 11 core emotions that I believe everyone experiences during their lifetime, from anger and guilt to anxiety and trust. Alongside these, I have added drawing prompts to help inspire you and get you connecting with whatever emotion you are trying to express. These prompts are designed to help you respond more intuitively to your emotions.

You will find many more prompts and inspirational quotes from artists in the third section of the book, which reflect the themes raised by the core emotions. Each of the prompts will provide blank spaces for you to fill with your own intuitive drawings. If you find yourself so inspired that you need more space, there are several completely blank pages at the end of the prompts for you to fill as you want, or you can use a separate blank journal to continue your continuous line drawings.

The most important part of this journal is about allowing yourself the space to draw, feel and create. Take your time, as not all emotions are easy to tackle, so please be kind and gentle with yourself. Give yourself permission to feel without judgement. If any particularly difficult emotions and memories rise up for you, please seek the professional support you need. I have provided some resources at the back of the book if you need a helping hand.

But most of all, I hope you enjoy intuitive drawing! As you will discover, this is a practice that everyone can do on a day-to-day basis, without the need to make any special preparations or buy lots of expensive materials. Please make this book your own, a unique expression of who you are: customize it, scribble and doodle all over it – in the blank spaces, in the margins – and dip into each part of it in the way that suits you best. I believe we're all creative and I hope this book can help you be creative too; the truth is that you are capable of anything!

THE
DRAWING
TECHNIQUES

"ART IS A LINE AROUND
YOUR THOUGHTS."

GUSTAV KLIMT

GETTING STARTED

We may not always realize it as adults, but drawing very likely played a major role in our cognitive development when we were children, helping us learn to think creatively and conceptualize ideas. Drawing has a number of other benefits too, including improving communication skills, reducing stress and helping to enhance our creativity. In art, drawing frequently lies at the root of a more complex work or idea, which may start with a simple sketch or doodle.

You don't need to have any artistic experience to make marks on a bit of paper with a pen or pencil – and that's part of the beauty of continuous line drawing, which simply means drawing without taking your pen or pencil off the paper, and just letting the line flow.

The following six techniques all use continuous line drawing and are designed to be as accessible as possible. They are versatile, enjoyable and deceptively simple to do, yet can help shift our feelings and thoughts in profound ways. As you will discover, there are many different things you can do with them – from expressing your feelings through making abstract marks and patterns, to depicting physical objects, people's faces and even whole landscapes.

Sometimes it's hard to put how we feel into words, but with drawing there's no right or wrong way to create. For each technique, I've shown some examples of drawings I have created, and then I've provided space for you to have a go and experiment. Your creation may be completely different from mine, and that is completely okay – in fact, I actively encourage this! Don't worry about the outcomes; nobody is judging you and there are no rights or wrongs here. Feel free to use whatever medium you have to hand – pen, pencil, crayon, charcoal or paint.

REPEAT MOTION

Repeat motion isn't about creating pictures of what you can see, but about making marks that relate to how you feel at a very raw level. It can be a good way to start if you ever find yourself feeling intimidated by a blank piece of paper. All you need to do is to take your pen – or whatever medium you're using – and move it to and fro without lifting your hand from the paper. Once you've made lots of marks using the repeat motion, you can always draw over them, or make them part of another drawing.

I use repeat motion a lot when I am experiencing challenging emotions such as anger, as this technique can be a good way to let your feelings out. It allows you to press hard into the paper, moving your hand back and forth quickly, which can help to release any pent-up anger or aggression you may feel. At the other extreme, when used with a light touch, it can be a meditative process, creating slow and subtle movements that link with being mindful and calm.

REPEAT PATTERN

Repeat pattern involves letting the line flow in the loose form of waves, loops or zig-zags. Using continuous line drawing, let your hand move across the page as though dancing in time to music or your heart beat.

Sometimes, when I've drawn a repeat pattern I've found that its repetitious nature can become numbing in a mindful way, because the technique doesn't require a lot of concentration yet it can distract the mind from negative feelings. In the same way that repeating mantras can still the mind, in this technique you are just focusing on repeating the pattern, which brings calmness, while helping to you to focus without drifting off.

SHAPES

To draw shapes, let your hand go for a wander over the page, much like you did in the repeat pattern technique. However, this time, see if you can form a repeat pattern of distinct shapes such as circles, squares, triangles or diamonds.

I have found the practice of drawing shapes particularly helpful when practising mindfulness techniques such as belly breathing. For a description of how to do this, see "Calm" (pages 62–65).

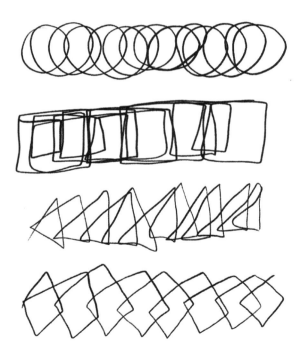

SPIRALS

Drawing spirals is simple but can be very rewarding, as the experience can feel very soothing and meditative. Interestingly, the spiral is an ancient symbol that dates back to the Neolithic period, making it the oldest geometric shape in art. Spirals are found everywhere in nature too – from the patterns of petals and the whorls of shells, to the formations of entire galaxies.

Some natural spirals may follow the Fibonacci sequence, which is one of the most famous formulas in mathematics. In the Fibonacci sequence, each number in the sequence is the sum of the two numbers that precede it, and this in turn is the basis of an important design concept known as the Golden Ratio. It is perhaps no surprise that the spiral is a key symbol of change, life cycles and development.

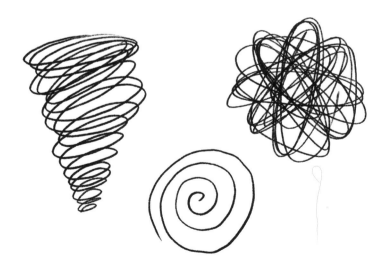

FACES

When you get more comfortable with mark-making using the continuous line technique, you may like to have a go at drawing faces this way. Faces are one of the first things that we learn to draw as children, but instead of a circle with two separate dots for eyes and a line for a mouth, I want to invite you to draw all the parts of a face without lifting your pen from the page, so that each feature flows into the next. You can focus on a single profile, or you can draw connected strings of faces and profiles in the same way we looked at drawing shapes.

Even if your doodles look nothing like the real people in your life, drawing faces can be a good way to represent those individuals about whom you may harbour difficult emotions, as this practice can offer a way to reflect on and even express those feelings safely.

Sometimes, seeing our own selves represented in our drawings can help us to connect with the emotions and feelings we may be trying to express. At the beginning of my healing journey, I used to draw faces regularly to help express my feelings, as I could see aspects of myself reflected in all of those images.

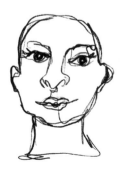 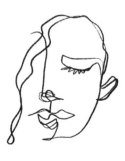

OBJECTS

Some mindfulness practices invite us to gaze at a candle as a way of stilling our thoughts. In art, we can gaze at our surroundings in order to focus our minds and, in this way, allow feelings and thoughts to arise naturally so that we can process them calmly. Or we can simply give ourselves permission to doodle, and see what objects emerge on the paper. I use the continuous line technique to draw a lot of objects, especially plants, in my work.

The practice of drawing objects, whether real or imagined, can help you to visualize an experience, and make something abstract – like an emotion – feel more tangible. Drawing objects can even offer comfort and warmth if the objects in question hold some sort of sentimental value for us. However, if you do find yourself drawing objects, keep using the motion of continuous line drawing, and don't be tempted to lift your pen off the paper. Just let the line flow, whatever you are drawing.

THE CORE
EMOTIONS

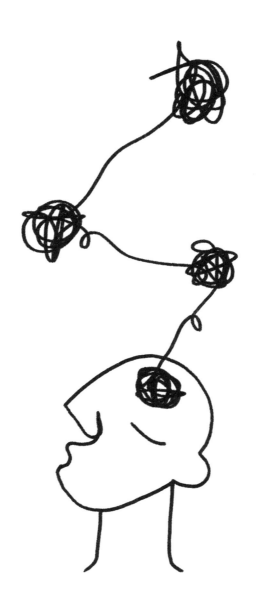

GET INSPIRED BY YOUR FEELINGS

As this journal is all about emotions, I'd like to take a closer look at 11 of them and the ways in which they can affect us mentally, physically and even socially. Emotions are powerful forces that influence nearly every aspect of our lives – from how we communicate with ourselves and others, to how we behave in certain situations. They may overwhelm us at times, yet they can also help us cope with life's challenges. They allow us to empathize with others as well as share joy or pain, helping us to let others know when we are sad or in need of help.

During the course of my counselling journey, I always thought that I had to talk about the more challenging emotions in my life, but then I realized that it is just as important to celebrate the positives. That is why I'd like us to look now at a range of emotions – from difficult feelings such as fear and anger, to uplifting emotions such as calm and happiness. I've learned from experience how drawing and creating can help to describe and express my feelings, and you will find examples of my own drawings of the core emotions in the pages that follow. Being able to walk through how I felt when I was drawing helped me connect with my own emotions – and I hope the same will be true for you too.

For each emotion, I talk a bit about how that emotion might manifest in your body and how it can be expressed using continuous line drawing techniques, using my own drawings as examples, before giving you space to draw and a prompt to help you feel inspired. I often use different colours to represent each emotion – for example, red for anger or green for jealousy. My drawings have been added to this book in black, and so I've added a caption below each one to let you know my thought process and what colour pen I used. I encourage you to play around with colour in your intuitive line drawings as well.

FEAR

Let's jump in the deep end by starting with fear. Fear is an intense emotional and physical reaction to something that appears harmful, alerting us to possible danger. Our physiological reaction could even take the form of the "fight, flight or freeze" response, which is a survival mechanism that releases a flood of stress hormones and causes us to tense our muscles and increase our heart rate – which is useful if you happen to stumble across a saber-toothed tiger in the woods; less so if you have an exam to pass. Fear can also be linked to anxiety, as it is caused by the worry about what could happen, rather than what definitely will happen – which is one reason why the American psychologist Susan Jeffers famously advised people to feel their fears and act in spite of them!

If left unchecked, fear can harm us physically and psychologically, taking over our everyday lives. Simply refusing to take any risks due to this fear can lead to missed opportunities. We need to step out of our comfort zones occasionally if we are to stand a chance of turning our dreams into a reality. If we allow our fear to overwhelm us, we stay stagnant, whereas we need constant movement in our lives to help shift the energies in them and attract new experiences.

When we are taking risks, it is important to remember that it's okay to fail; in fact, an important part of life is about encountering failure and developing resilience. After all, when we fail, we learn something about ourselves, which we can then take forward to the next experience. I have found that if we continue to confront and conquer our fears, this in turn creates a new pattern of thinking

that can help us to make progress in our lives. However, this may take time and lots of patience.

A counselling tutor once told me to "take my thoughts to court", which is brilliant advice for tackling fears and anxious thoughts. In court, you must provide evidence for your fear and whether it is justified. This is a good grounding technique and can be a useful way for you to examine your fears comfortably. For example, I used to be afraid that I would have a panic attack at work. When I took these thoughts to court, I presented evidence to myself that this had never happened, so there was no proof to suggest that I would have a panic attack any time soon.

When I draw fear, I often represent it as a repeat pattern of squares. This because when I experience fear, it feels very tight and rigid to me. I used a black pen and I have kept my lines heavy to represent power and darkness because to me, fear feels like a weight on my shoulders.

With fear comes panic. What creates panic and fear within you? Think about how you react when you feel fearful – do you run away or do you attack?

Beginnings can often seem frightening – and when we are drawing, the hardest part is often making the first mark on a blank piece of paper. Using the six techniques we've looked at, start covering this page with as many doodles as you can! Can you feel your fear turning into something else?

GUILT

However it manifests itself, guilt is a self-conscious emotion that can involve intense distress and even a sense of failure, making us feel overwhelmed and anxious. In fact, it can appear in many different guises if it remains unresolved. Whether we are conscious of it or not, it can cause anxiety, low self-esteem, resentment and depression, and affect our bodies in various ways, too. Symptoms can include problems with sleep, muscle tension and stomach and digestion issues.

In a gentler form, guilt can present itself as feelings of remorse or sadness relating to past actions and experiences. Perhaps most straightforwardly, it can occur when we know we are responsible for a wrongdoing, such as bending the rules or breaking the law, or when we feel ashamed of our behaviour. However, we can sometimes feel guilty and blame ourselves for situations that are out of our control, or that we play no real part in.

In fact, sometimes we may feel guilty for asserting ourselves and putting ourselves first, which is something I believe most of us don't do enough. For example, I started to feel guilty when I began to put my needs and wants first, and stopped people-pleasing so often. I realized that it's important to remember that if we say yes to something or someone when we really mean no, we may be trading feeling guilty in the present for feeling resentful in the future.

Whatever its cause, guilt extends an invitation to look closely at our responsibilities, particularly in relation to past actions. Acknowledging

a mistake is such a brave thing to do. However, where guilt says, "You made a mistake", and then holds us to ransom, acceptance says, "You will learn from your mistake", and allows us to let go and move on. Only when we acknowledge and accept our role in a situation does the process of healing and forgiveness truly start.

Sometimes even when we try to take responsibility for our actions and fix any damage we've caused, the guilt won't go away. Yet, even if you can't forgive yourself immediately, with time things may feel a little easier, especially if you are able to receive the right support. If you are struggling with guilt, you may find that therapy can offer an amazing way to address those feelings openly and honestly in a safe space.

Even though I have worked hard on it, like all of us, I still struggle with guilt at times. Today, I find that simply saying out loud "I forgive myself" can be a way of affirming self-forgiveness and letting go of guilt. You might like to try this too – it helps if you stand in front of a mirror as if you are directly talking to yourself!

Guilt can feel like a never-ending loop of anguish that keeps us trapped, which is why I've used the repeat motion technique to illustrate this loop. I used the colour black to represent the pain of this emotion, and a thick pen pressed hard on the paper to create a ring of scribbles.

Have you ever felt guilty about
something you can't control?

Think of a moment or situation that makes
you feel guilty, and draw this out. You could
draw where you feel guilt in your body, or, if
you prefer, rather than try to draw a person or
a scene, you could use the same repeat motion
technique that I did to capture the essence
of this feeling for you.

TRUST

Having trust in someone, or something, can often push us to the edge of our comfort zone. It requires us to place our confidence in something other than ourselves and in situations outside of our control, without certainty or a guarantee, which can leave us feeling exposed or vulnerable. However, trust is a beautiful emotion that is closely bound to our love for others, ourselves and our hopes for the future. We should do everything in our power to help it to grow!

As an emotion based on faith, trust is delicate. Once damaged, trust can feel difficult to rebuild. We might have placed our trust on something in the past and feel that it was betrayed or not handled with the care that we would like, leaving us reluctant to trust people in the future or place ourselves in situations where we are required to trust again. Perhaps we told a secret to a friend in confidence, only to find that they shared it without our consent, or had our feelings hurt after the trust we placed in a romantic relationship was broken.

Without trust we can feel isolated and lonely, and we also risk transferring our lack of trust on to future relationships. It is so important to continue to place trust in others and to try and repair bonds of trust that might have been broken, even if this might feel daunting. Repairing trust can

be a slow process, but if we keep an open mind, communicate and do things that build trust, like confiding in others, it can be restored. If you have someone close to you who has trust issues from past experiences, encourage them to place their trust in you by rewarding them with the care, love and support that they deserve.

We also need to have trust in ourselves, in our strengths and abilities. A lack of self-trust can be linked to low confidence in what we have to offer and the value of our thoughts and opinions. Remember to always have trust in yourself – you have a set of skills, characteristics and capabilities that are precious and unique to you!

● Trust is often linked to a circle, as it can never go in just one direction but must be given and received in equal measure. I have drawn trust here using a mix of circles and squiggles. I used a deep blue because this colour is associated with loyalty, security and honesty.

Think about a relationship in which you have a strong bond of trust, and use the shapes technique to draw a circle that represents this. Next, draw another circle, this time thinking about a relationship where the bond of trust has been damaged. Can you see a difference in how you have drawn these two circles of trust? What can you do today to reach out and strengthen the trust in these relationships?

JEALOUSY

Jealousy's link with the colour green is believed by some to date back to ancient Greece, when it was thought to occur as a result of the overproduction of bile – which would turn the skin green. Hence "green with envy". Whether or not it has anything to do with bodily fluids, jealousy can manifest itself in low self-esteem and obsessive thoughts. Insecurity, fear, lack of confidence, feeling threatened, unrealistic expectations and how we value ourselves can all be deeply rooted in jealousy. It's an emotion that can cause us to have raised blood pressure, increased heart rate and even anxiety.

Jealousy can also make us behave in ways that do us no favours. There is a character called Iago in Shakespeare's play *Othello* who describes jealousy as "the green-eyed monster which doth mock/The meat it feeds on." I don't often experience jealously, but when I do, I find that social media can be a strong trigger for me. If I'm not careful, it's easy to waste precious time wishing that I could enjoy the sort of work opportunities or travel experiences that others have, rather than focusing on my own plans. This is why I have made a conscious decision to spend less time on social media.

Online, we are constantly bombarded with images of "perfect" lives, which then feed us with unrealistic expectations and ideas of what our own life should be like. I have even come across people who use fake images to keep up with the façade of enjoying a so-called perfect, successful life – which means that there is really no reason to be jealous of those glamorous photographs at all!

Like anger, jealousy can stir up the body's stress response and can feel overwhelming. If you become overcome by jealousy, it might be worth examining the root causes of these feelings. Try to approach your emotions with compassion and integrity, as the powerful sensations associated with jealousy can sometimes blind us to the full picture. And talk to a trusted friend about them; it's a good idea to get another view, as this might make you look at things from a different perspective. Finally, voice your concerns, even if you don't like admitting to this emotion. It's always important to talk openly and honestly, no matter how uncomfortable you may feel.

To me, jealousy feels really awkward, uncomfortable and constraining – almost like a chain. For this reason, I've symbolized this challenging emotion by using a back-and-forth motion to create a lots of swirls. Like many others before me, I associate the colour green with jealousy, which is why I drew this emotion using a bright green.

What triggers jealousy for you? Do you get jealous of people or certain situations? Think about this for a little while, then start using one of the techniques we've looked at, channelling your feelings through your pen or pencil onto the paper. I would be inclined to use the colour green for this drawing but feel free to use whatever colour feels right for you.

DISGUST

Disgust is another difficult emotion that can manifest itself physically. When I think of this emotion, I immediately imagine someone throwing up. Interestingly, disgust evolved in early humans as a protective mechanism to keep us from becoming ill from eating rotten things. It's as true today as it was for our cave-dwelling ancestors: the smell or appearance of a piece of rancid food stops us from eating it, thereby preventing possible sickness and even death. What a brilliant way our body has of keeping us safe and healthy!

However, in modern society disgust can manifest itself in many different guises, not only around potential food or body functions. Instead, it can be focused on how people behave toward each other, anything potentially poisonous (including relationships) and anything considered ugly. We can feel disgust about a situation, a person or even ourselves – which can be a particularly painful form of disgust to experience. Self-disgust is often coupled with shame and self-contempt, but we can start to tackle this by acknowledging any judgemental thoughts that pop into our head.

The same applies to other forms of disgust. While it's okay to feel disgusted about things, it can be a particularly difficult emotion to cope with at times, especially if it is directed at ourselves. Once we become aware of it, we should ask ourselves why we feel this way and how it is affecting our minds and bodies. For example, if something is not harming us, then why do we feel disgust toward it? Pausing to

consider the reasons behind an emotion can help us validate it, question it and even unearth the possible root cause of it.

Although disgust can play a positive role in keeping us safe, it can also make us feel distant from others. It's an emotion that is usually related to judgement in some way, and the truth is that we all judge ourselves and others, whether we think we do or not. I remember feeling disgusted with myself as a young person when I was mean to others, even if this was unintentional. However, I never knew what to do with this emotion or where to put it. I also remember feeling disgusted about other people's behaviours, but this emotion gradually went away when I came to recognize that a form of harsh criticism often accompanied my feelings, which then allowed me to step back and try to understand myself and others better.

I've represented disgust using lots of jagged swirls to mirror the churning in my stomach. I used the colour green to denote the sick feeling that can occur when we experience disgust.

Disgust is often accompanied by some common facial expressions, such as wrinkling up our noses and turning down the corners of our mouths. We may also use noises to inform those around us of our disgusted feelings.

Can you think of something that makes you feel disgusted? Let that feeling flow out of you now, down your arm, into your hand, through your pen or pencil and onto the page in the repeat motion technique. As you draw, allow yourself to make any disgusted noises that you like!

ANGER

Anger makes my heart race and I can't sit still. I nearly always end up crying to release this strong emotion. For other people, anger may feel like a tightness in the chest or a churning in the stomach. Your jaw may clench, your body stiffen or tremble and your face may flush with the heat of your fury or – at the other extreme – grow pale. When we are very angry, we may even feel afraid of ourselves, of losing control and not thinking clearly.

Anger can have many causes, including fear, pain and frustration. If left unaddressed or ignored, it can become toxic to both ourselves and others. If we hold onto it and take it inward, we can seriously harm ourselves. As the Buddha says: "'Holding on to anger is like grasping a hot coal with the intent of throwing it at someone else; you are the one who gets burned." We need to release anger while being careful where it is directed.

A powerful emotion such as rage can be very damaging when aimed directly at others. For this reason, and as some people may express their rage by throwing things or breaking objects, I have always thought that "rage rooms" are very beneficial for expressing and relieving anger. These are spaces that you can rent where you have permission to smash anything you want – and you can feel safe while doing it. Whatever your situation, try to direct your anger at inanimate objects or in ways that can't harm others. By acknowledging it and trying to understand it, we can learn to express it safely.

While anger is a powerful emotion that can sweep us away if we aren't careful, it can also be used for good. One positive aspect of anger is

that it allows us to express ourselves in obvious ways to others. It can ignite action for change and energize us to find solutions for problems. Another productive way to express anger is through sport. If it appeals to you, channel your anger into an activity where you can really push your limits, mentally and physically, such as running or swimming.

A less physical way of channelling anger creatively is through journaling, whether by writing down words or through working with clay, paints and drawing. These sorts of artistic activities can allow you to express your emotions in more physical ways. "Paint rooms", like "rage rooms", give you a much bigger canvas to work with, enabling the use of your whole body to express any anger you feel. They can also allow you to tap into hidden, deep-rooted emotions, which writing can sometimes miss, and, like sport, leave you with a sense of exhaustion but also calm when you have finished.

🔴 I tend to see anger as an eruption of feelings, which is why I used the colour red for this drawing. I also moved my pen about rather aggressively, exerting lots of pressure on the paper to alleviate any rage I felt. In fact, now I think about it, the drawing looks rather like an explosion, which is an apt depiction of how I experience anger.

Think of the last time you felt anger. Did you feel angry at someone or something? Was there a sudden trigger or something that slowly built up?

Tap into those emotions now, and pick up a pen or pencil to express how you feel. Using the repeat motion technique, make marks with force all over the page so that the anger is transferred from you to the drawing tool to the paper. This simple process may help you understand yourself and how you experience anger.

CALM

Calm, though not always recognized as an emotion in the purest sense, is an important feeling that connects closely to the presence - or absence - of other emotions. It is probably one of my favourite feelings. When I am calm, I usually experience a sense of contentment, and I feel like a tranquil sea or a gently flowing river in a forest. This may be why I always associate the colour blue with calm.

When we are calm, we can think more clearly; we feel peaceful and relaxed. Calmness soothes us physically too, slowing our heart rate and lowering our blood pressure. Taking a moment to calm ourselves can help us to relieve tension by giving us the space to respond in a measured way to situations, rather than with knee-jerk reactions.

Some ways we can cultivate calm include giving ourselves a break, both mentally and physically. Meditation can be difficult when your mind is racing, but we can practise mindfulness simply by learning to stop, take a deep breath and notice what is going on around us in the present moment. This simple practice can help develop calmness in our body and mind, as can belly breathing, which I am going to invite you to try in a little while.

Sometimes focusing on an activity such as drawing can be a good way to experience mindfulness, as this can allow us to narrow our focus, calm our minds and be more present and relaxed. It is useful to remember that what is

meant for you in your life should always feel natural, calm and clear – not forced, chaotic and confusing. So it's a good idea to make conscious, mindful decisions that support your calmness and to deliberately keep away from those that may lead to chaos.

● **Here, I've drawn calm using big circle-like motions. While I was drawing, I focused on my breath and used this to guide the motion of the pen on the paper, so that every time I breathed in I moved up the paper and then, when I exhaled, I came back down the page, which created that looping motion. I used a calming light blue that mimicked the sea and river I so often picture with this emotion.**

Belly breathing is a great technique for finding calm and becoming present. Also known as diaphragmatic or abdominal breathing, belly breathing simply entails inhaling slowly and deeply through your nose, and pulling the air down into your lower belly. Then exhale slowly through pursed lips.

A really great way to cultivate calm is to combine belly breathing with drawing shapes, as I did on the previous page. Focus on repeating the motion and use the corners of the shapes as points at which to either exhale or inhale. Why not give this a go right now?

ANXIETY

Anxiety is something that feels very close to home for me. Since 2019, I have experienced anxiety on a day-to-day basis for several reasons, and I'm continuing to tackle this emotion.

Anxiety can cause a high heart rate, sweating, headaches and nausea, leading to stress and panic. It often stems from negative thoughts about the future; it's about the "what ifs" and the worries associated with these. However, we can also suffer from anxiety disorders stemming from unresolved past trauma, which, when triggered, can similarly lead to stress and panic, making us feel boxed in.

While feelings of anxiety are completely normal and something that we will all experience at some point in our lives, when this emotion becomes unmanageable, overwhelming or appears out of nowhere and lasts for long periods of time, this could be a sign that we need to reach out for help. Therapy can be a massive support when it comes to tackling anxiety and, as you may have guessed, I can't recommend it highly enough. I also know people who have benefitted from combining talking therapies with medication to treat this condition. However you choose to tackle it, it is useful to know and recognize what your triggers are and what the anxiety is directed toward.

Anxiety can often distort our relationships with our sense of intuition, making it difficult to distinguish our intuitive insights from what may be unfounded worries.

The truth is that worrying won't change the future. That is why learning how to tell the difference between our "anxiety voice" and our "intuition voice" can be an important part of our healing journey, as this can help us to accept that not every unwelcome thought is destined to become our reality. I have found it very helpful to pause and ask myself things like, "Is listening to this voice helping me or sabotaging me?" If you try this too, you may find that it helps you navigate a situation or make decisions that lead to a better outcome. This is one reason why, despite its challenges, anxiety has taught me a lot about myself that I am very thankful for.

Anxiety feels like a huge knot in my stomach that I can't unravel. This is why I have drawn anxiety here as a black knot, as I nearly always see it is a tight ball of scribbles. It's like a big ball of string that you can't easily untangle without lots of time and patience. Whenever I draw a person who is suffering from anxiety, I often show them with this knot in the stomach or head.

I sometimes find it helpful to visualize anxiety as a little worry monster – a tight knot of scribbles with eyes. When I do this, it gives a form to my feelings that makes them seem a little less uncomfortable and overbearing.

What makes you feel anxious and how does this manifest itself? What does anxiety look like for you? Take your time with this emotion as it's an uncomfortable one that's a bit harder to sit with. Then, when you are ready, use the continuous line technique to sketch your own worry monster. As it's a monster, it can take any shape you like.

LONELINESS

Throughout history and all around the world, humans have mostly lived in groups that meet our basic emotional and physical needs. Being part of a tribe has benefitted us in many ways, offering us safety and security as well as a sense of purpose, wellbeing, support, community and belonging. Although many of us live by ourselves today, there are very few people who would actively choose to live in complete isolation. Loneliness has been described as a social pain, as even if our physical needs are met, being cut off socially from a group can harm us profoundly in other ways. Research has linked loneliness to a range of physical and mental conditions, including heart disease, anxiety, depression, a weakened immune system, cognitive decline and even premature death.

There are many different types of loneliness and you may be familiar with at least one of them. Emotional loneliness stems from the absence of somebody close to us, or that we have a meaningful relationship with, while social loneliness involves a lack of interactions with neighbours, work colleagues and friends. Situational isolation can occur at certain times of the year, such as Christmas, weekends and bank holidays, when people tend to gather in groups and, if we are on our own, we may feel excluded from what are supposed to be joyous occasions.

Deep loneliness can be triggered when you do not feel truly seen, heard or understood. This can be particular painful – especially if you are someone who craves closeness. Meaningful conversations are helpful if you are feeling like this, so it is important to seek

out people who can truly hear and see you. There are a lot of ways to combat loneliness if you feel like it is negatively affecting your life. You can join art groups, volunteer or even spend some time in nature – I never feel truly alone when I am surrounded by trees. If you feel shy or socially awkward, take small steps at first and then work your way up to bigger social events.

Sometimes we may be alone without feeling lonely. Instead, being on our own can give us the opportunity to enjoy some free time just being ourselves without worrying about the opinions of anybody else. This sort of loneliness can be very liberating and allow you to find out things about yourself that you never knew. When I think of this type of loneliness, I sometimes visualize it as vines and flowers growing, as it has truly allowed me to bloom. I used to find being on my own difficult and it would make me feel depressed, but through therapy I have grown to love it and am now able to sit with myself and be my own best friend, which is a wonderful position to be in.

Here I've used the continuous line technique to represent loneliness in the shape of a circle that resembles a hole, as when we feel lonely it can seem like we're stuck in a hole with no way out. I used a muted purple colour to represent the dullness of loneliness.

When do you feel most alone? What is going on around you when this happens? Do you feel more alone when you are by yourself or in company?

Imagine your loneliness as a drawing; can you use one of the six techniques to bring it to life on the paper? Perhaps loneliness feels like a particular form to you that you can draw using the shapes technique?

SADNESS

There are lots of ways in which we can feel sad. After all, it's a completely natural reaction to any situation that causes emotional pain or upset. Death and endings can be a major cause of sadness, as can trauma, disappointment and rejection. With time, the intensity of sadness will usually lessen. However, if you find that you are losing interest in various areas of your life, and you feel like your emotions are taking over and becoming unmanageable, you may be suffering from some form of emotional turmoil or trauma. In that case, it might be best to reach out and seek professional support.

As well as impacting us emotionally, filling us with negative thoughts and making us unable to concentrate, both sadness and depression can cause us to lose energy. Feeling heavy, the slowing of movements and even wanting to isolate ourselves from the rest of the world are all symptoms of feeling sad or depressed. This may manifest physically, in the form of a distinct sensation or a pain in our chests, like a heavy weight has been placed on our bodies.

While sadness can be closely linked to depression, some cultures deal with it quite differently. For example, traditional Chinese medicine takes a holistic approach by looking closely at the connections between a person's mental wellbeing and physical health, and may use treatments such as acupuncture – inserting very thin needles into the body – to address a mental health condition such depression. I have also learned through my own counselling training that it is useful to look at all aspects of a person's life in order to identify where there

is any imbalance and how this could be affecting every aspect of their health, whether emotional or physical.

Whenever I feel sad, I try my best to be okay with the sadness I am experiencing, although this can sometimes be difficult to do. I try to be as kind and gentle with myself as possible, moving slowly and doing whatever feels best for my mind and body. One of those things could be making myself a lovely, wholesome meal. Diet can also influence our mood, and I know that good food makes me feel wonderful.

As you take the necessary steps to process and heal your own hurt, your symptoms will hopefully decrease. This is why in tough times it is always important to remember to be gentle with yourself and to sit with these emotions. This feeling will pass, but it may take time – and that's okay.

● Whenever I feel sad, I always seem to draw a lot more. I used a dark blue in this particular drawing as well as a continuous circular motion, as that's how sadness can sometimes feel to me – like a constant emotional pull that keeps returning.

Can you go back to a point in your life when you felt sad? Are you able to touch lightly on this sadness and bring it into your drawing space, using the repeat pattern technique? It doesn't have to manifest in circles — you can use whatever shape your sadness feels like. If tears come while you are drawing, let them flow.

HAPPINESS

How we experience happiness may differ from person to person, but most of the time it is easier to feel happy when we are content and satisfied with our lives. Feeling gratitude, living in the moment, positive thoughts and going with the flow are all signs of being happy.

The old cliché is true: we can't buy happiness. Genuine happiness comes from within, and it can be a slow process to find it; we live in a world so full of distractions that it may take a long time to discover what happiness really means to you and how to maintain it. So how will you know when you've found it? Mahatma Gandhi once said: "Happiness is when what you think, what you say and what you do are in harmony." I love this quote as it relates to the balance of our physiological and physical feelings. I try to find this sort of balance during my day-to-day routine by practising mindfulness through swimming, drawing and dancing to connect with my body. Through these sorts of activities, I feel like I am investing in my health and myself.

For me, moments of happiness can be big or small. I consciously try to find something to be happy about at least once a day as I find this grounds me and encourages me to be grateful for what I have in my life.

While happiness may be the ultimate goal, we probably won't be able to recognize what it looks like if we haven't experienced a range of other emotions too. It's important to remember that emotions are like

waves – they come and go – and to maintain a good balance of positive energy, we have to look at all aspects of our life. Negative emotions are there to keep us safe. For example, they may help us identify harmful relationships, unfulfilling work or health issues, and then motivate us to improve these areas of our lives, just as our positive emotions guide us toward leading more fulfilling lives.

A key step to finding happiness could include putting yourself first. This can be a hard one to do, as it means setting boundaries for yourself and doing what feels best for you. Also think about working on your mindfulness through activities such as belly breathing (see page 64), meditation, exercise or just enjoying a day to yourself. Booking a day off to do something you love will help you to maintain a healthy balance in your life. But if this isn't possible for you, try to take just five minutes out of your busy schedule to sit and breathe. Pick up a pen or pencil and doodle in this journal, allowing your feelings to flow onto the paper.

● **While making my happiness drawing, I focused on what brings me joy, and I've used bouncy and light movements to capture the feeling this gave me. I used the colour yellow as, for me, this fully encompasses feelings of happiness, of being bright and joyful.**

Think about the moments
that bring you joy. Is there
something or someone that
makes you feel happy?
Or even a particular memory
that brings you joy? While
thinking of this, draw out
how it makes you feel.

THE
PROMPTS

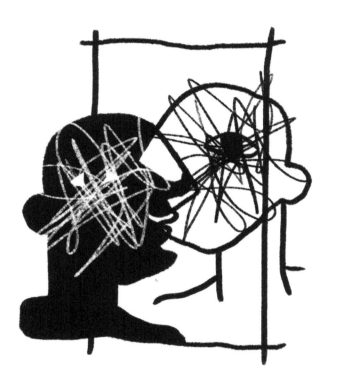

INSPIRATION FOR YOUR DRAWING

Now that you've gone through the techniques and looked closely at how you can represent different emotions with your drawings, it's time to look at a variety of prompts to inspire you to keep drawing. The following pages will not only provide you with a wide variety of prompts, but also quotes from famous artists to form part of a gentle questioning process that is designed to help you reflect on your emotions. For example, you might have lost control through anger or experienced great sadness caused by loss. Reflecting on these sorts of emotions will enable you to express them and process them. In addition to this, you will see that some of the prompts consider positive emotions such as calm and happiness, as these are an equally important part of your healing journey.

The prompts are set out in no particular order and I would encourage you to work with them in whatever way suits you best. This is because many of us may start to journal without knowing exactly how we feel, and while we may want to work through certain situations in our lives, we may not know exactly which emotions they relate to. In the same way, people tend not to tackle one emotion after the other during a course of therapy, but instead different issues may come up for them at different times.

As you work through the prompts, remember to keep looking back and chart your progress. It will be interesting to see what feelings arise for you through the process of intuitive drawing and the creative ways in which you decide to explore these emotions. In time, it may be nice to look back over the whole book to see how you responded to the various prompts and how you expressed different emotions. This could be a great opportunity to reflect and think about how you'd like to explore emotions in the future or tackle them in healthier ways.

Music can be very uplifting. Put on your favourite happy
song now and draw to that. Can you draw the sounds you hear?
See what flows from you onto the paper, using the repeat
motion, repeat pattern, shapes and spirals techniques.

"I WOULD LIKE TO PAINT
THE WAY A BIRD SINGS."

CLAUDE MONET

Think of a situation that makes you anxious. How does it feel in your body? Using a thick black pen and the repeat motion technique, scribble that emotion all over this page. Now take a pack of coloured pens or pencils, and very slowly and carefully colour in all the spaces between the lines until you begin to feel calmer.

Can you think of a something that brings you joy?
How could you draw out your joy? Draw something
now that makes you smile.

Fear can feel like a physical presence, a shadow that follows you around or a weight on your shoulders. It may help to imagine our emotions as a physical being or an object in order to understand them and feel more comfortable with them. Think of a specific fear you have, and draw something that represents this fear, using one of the techniques we have learnt.

"I NEVER PAINT
DREAMS OR
NIGHTMARES.
I PAINT MY
OWN REALITY."

FRIDA KAHLO

For me, the feel and texture of certain pens and pencils are important. I encourage you to explore oil pastels, pens, paints, biros and even materials found outside like chalk and mud. This could help you connect with your creativity and let go. Make a conscious decision today to play with different materials either on this page or a separate piece of paper.

This about all the worries you're currently juggling –
let's put them in a worry cloud! To do this, draw a little
cloud using the continuous line technique. Then take
a moment to project your worries onto it.

Next, transform your cloud to show it being blown away
in the wind – in the knowledge that it is possible for you
to transform your worries in much the same way.
(If you want, you can draw your worry cloud on
a separate piece of paper, and rip it up!)

Jealously often arises when we compare ourselves unfavourably to others, and can indicate low self-esteem. But the truth is that other people might be jealous of us! Self-portraits are always interesting to draw, as how we see ourselves can be very different to how others see us. Using the continuous line drawing technique, use the space opposite to try drawing your own face, focusing on the features that you like best.

Here you can see a self-portrait that I have made using this method.

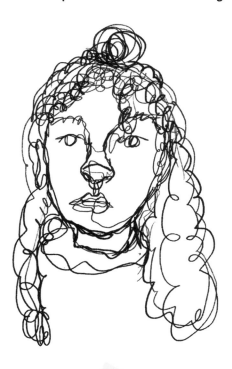

Trust is a delicate emotion that needs to be tended and nurtured. Use this space to create your own garden of trust. Pick a coloured pencil to represent your strong relationships and, beginning on one side of the page and moving the pencil continuously, draw a row of flowers while thinking about how these relationships make you feel. Taking another coloured pencil and repeat this process from the other side of the page, this time considering the relationships you have that may be lacking in trust.

"DRAWING IS LIKE TAKING
A LINE FOR A WALK."

PAUL KLEE

Is there someone who used to be important to you, but who is no longer in your life? Using the faces technique, close your eyes and create a drawing to represent them – it doesn't need to be a realistic likeness! Is there anything you can do to recreate this lost connection, if that is something you want to do? Or to heal it?

ARTIST'S TIP

ACTIVELY LOOK FOR WAYS TO CONNECT WITH OTHER
ARTISTS. THIS COULD BE THROUGH JOINING AN ART GROUP.
PERHAPS YOU HAVE A CREATIVE FRIEND WITH WHOM YOU
CAN SHARE DRAWINGS, TAKING TURNS TO SET YOURSELVES
PROMPTS FROM THIS BOOK. REACH OUT TO FIND PEOPLE
THAT YOU CAN SHARE YOUR CREATIVE IDEAS WITH.

If guilt had a shape, what would it be? Would it be soft and sagging, like stale cheese, or hard and brittle, like shards of ice? Can you draw this out using the shapes technique?

Hands are frequently portrayed in art. They can represent strength, creative energy and protection. In spirituality, individual hand gestures can also symbolize generosity, hospitality and stability. Place your hand in the centre of this page, draw around it, then write down five things you are good at. If you need to do this on a piece of paper, stick it in here after. Remember that you are powerful.

Drawing with your eyes closed can be a great way to connect with your body in the moment. Take five deep breaths, close your eyes and draw anything that comes to mind across both of these pages. When you open your eyes, you may find that your drawing looks a little messy, but that doesn't matter – it will be charged with an expressive energy all of its own.

Clutter and calm make for uncomfortable companions. It can be difficult to find calm when we are surrounded by busyness and distractions. Take a moment now to declutter the space around you. Next, make yourself a soothing hot drink. When you feel calm, draw an object using as few movements as you can, until you can capture it in the flow of a single vertical or horizontal line.

Let's explore your sadness on this page. We all have sad memories that we try to avoid thinking about. Take your time to consider one of these memories. Using the spirals technique, mentally walk through this memory from start to finish, drawing as you go. At the end of this exercise, think of one thing associated with this person, place or situation that makes you smile.

It's time to really let go and express your anger. Close your eyes and allow your biggest cause of anger to come into your mind's eye. Now get something messy – like charcoal or paint, or whatever you have to hand! – and cover both of these pages with a big, bold line. You can even combine this with sounding out how this person or situation makes you feel! Once you have done this, take a deep, relaxing breath and mentally move on.

ARTIST'S TIP

LOOKING AT YOUR ANGRY DRAWING, WHAT ELSE CAN YOU
SEE IN IT? WHERE YOU'VE APPLIED MORE PRESSURE, SEE IF
YOU CAN REMEMBER EXACTLY WHAT THOUGHT TRIGGERED
THAT SPURT OF ANGER.

Occasionally, there can be so many things going on in our lives that it's hard to distinguish between the different emotions muddling around inside us. The next time you feel overwhelmed by conflicting feelings, turn to this page and try to pick out the emotions, one by one. Use a different pen and colour for each one that you feel and try selecting the most appropriate intuitive drawing technique.

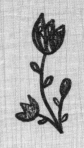

"EMOTION, WHICH IS
SUFFERING, CEASES TO
BE SUFFERING AS SOON
AS WE FORM A CLEAR AND
PRECISE PICTURE OF IT."

BARUCH SPINOZA

Fear is often associated with the dark, so deliberately close
your eyes and, keeping them closed, draw something that
symbolizes fear for you on the opposite page.

It can be as simple as you like; in my drawing below, I've represented
fear as a simple black hole with small blank dots for eyes.

When you are ready, open your eyes. What further thoughts and
feelings does your drawing give rise to?

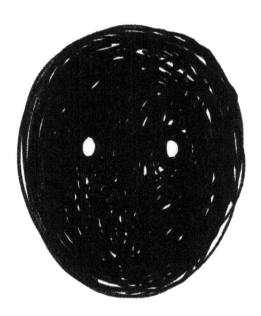

 ARTIST'S TIP

REMEMBER TO TAKE YOUR TIME WITH THIS JOURNAL.
EMOTIONS AND FEELINGS CAN BE HARD AND DIFFICULT
BUT THEY ARE PART OF OUR EVERYDAY LIFE. YOU ARE
MORE CAPABLE THAN YOU THINK!

Many believe that using our non-dominant hand can allow us to access our unconscious mind. Using the opposite hand to the one you usually write with, try keeping a blank mind (you can even meditate, if you wish) as you draw using the repeat motion technique, letting your hand pass freely over the page. Now, look back at the drawings you did in the core emotions section with your dominant hand. Can you see any patterns emerging?

How are you feeling today? Think of one thing that has made you feel good today and then draw it, whatever it is, using one of the continuous line techniques you have learnt.

We may be afraid of the unknown, but stepping out of our comfort zones can often lead to exciting new discoveries. Can you place your hand on a tactile object and, without looking directly at it, draw how it feels without lifting your pen off the paper?

"Entopic graphomania" may sound like a peculiar type of malady, but it is, in fact, a Surrealist drawing method and a great way to practise mark-making. To try it, get a printed sheet of paper, such as a page from an old magazine or newspaper, and then mark some of the words or letters with simple dots. Next, connect those dots to form a pattern, using straight lines or repeat patterns. This will show how negative space and seemingly random choices can come together to create a beautiful piece of art. Stick them to this page after.

We saw on page 50 how the colour green is often associated with jealousy. However, it is also linked with the freshness of springtime. Nearly everything has a flipside or possesses contradictory qualities. What is your favourite colour? Use these two pages to draw something that you covet in that colour, and then use the continuous line to transform it into another object.

ART CAN ACT LIKE A FINGERPRINT: THE WORK OF NO TWO ARTISTS IS EXACTLY ALIKE. NOBODY ELSE WILL DRAW OR CREATE EXACTLY LIKE YOU DO, SIMPLY BECAUSE THEY AREN'T YOU. INSTEAD OF FEELING JEALOUS ABOUT HOW OTHER PEOPLE DO THINGS, CELEBRATE EVERYTHING THAT IS UNIQUE ABOUT YOURSELF AND THE PIECES YOU CREATE.

Anxiety can cause you to experience looping negative thoughts, something that drawing can help to distract us from. We can begin to tackle anxiety by showing ourselves compassion and giving ourselves permission to take time out to draw. If you can, set aside some quality time this week to go out in nature and draw. Perhaps you could sit by a pond in a nearby park. All you will need is this journal or a sketchbook and a few coloured pens or pencils.

"LIFE IS A BALANCE
OF HOLDING ON AND
LETTING GO."

RUMI

Don't restrict yourself when you make art – feel free to use whatever materials are to hand. Artists such as Hannah Höch and Man Ray used photomontage and collage as a way to mimic the workings of the unconscious mind, in which different elements are combined to create something new. Start collecting scraps of paper from newspapers and magazines, or ripped-up old drawings of your own, and stick them on both of these pages to create a new random piece of artwork. Once you've stuck down everything you want, use one continuous line to connect them all, circling words images that are important to you.

Guilt often involves a sense of judgement – of being evaluated and found wanting. I've symbolized this here in my small sketch of watching eyes. What symbolizes feelings of guilt to you? Can you draw this out?

———✦ ARTIST'S TIP ✦———

IT'S USUAL TO SOMETIMES FEEL GUILTY THAT WE AREN'T ACHIEVING MORE. HOWEVER, WE NEED TO APPRECIATE THE PROGRESS WE HAVE MADE BY PAUSING AND REFLECTING.

122

In some forms of therapy, dreams are used to explore distorted thinking, as well as to examine how these sorts of thoughts relate to our waking life. What was your last dream about? Can you draw it out? Was it a nightmare? How did it feel – wonderful or strange?

We may feel guilty when we take the time to make art, but getting creative can help distract us from negative thoughts. It can also give us a clear way to express these negative thoughts emotions, and help to stimulate our senses. Take a moment now to enjoy a guilt-free doodle over both of these pages!

 ARTIST'S TIP

GUILT OFTEN ARISES OUT OF A SENSE OF OBLIGATION, OF
LETTING OURSELVES BE RULED BY "SHOULDS" AND "OUGHTS".
WE CAN START TO TACKLE THIS BY MAKING CONSCIOUS
DECISIONS ABOUT HOW BEST TO SPEND EACH MOMENT OF
OUR LIVES AND DEVOTING TIME TO THOSE THINGS THAT
REWARD US WITH JOY AND A SENSE OF FULFILMENT.

For many of us, school is where we begin to develop our individual personalities and learn more about ourselves. Think back to your first school memory. What were you doing? How did you feel? Using the objects technique, draw something that represents this formative period for you.

"WHAT I WISH TO SHOW
WHEN I PAINT IS THE WAY
I SEE THINGS WITH MY
EYES AND IN MY HEART."

RAOUL DUFY

We can sometimes become so lost in comparing ourselves
to others that we forget to appreciate what we already have.
Take a moment now to draw something you're good at,
or that you are grateful for.

GRATITUDE IS AN IMPORTANT PRACTICE. IT IS PART OF BEING POSITIVE AND CREATING A SUPPORTIVE PRACTICE IN OUR LIVES. IT CAN HELP US BECOME UNSTUCK AND LESSEN THE STRESS IN OUR LIVES WHEN WE THINK OF ALL THE THINGS THAT WE ARE GRATEFUL FOR.

Which colours do you associate with love and kindness?
Use them to draw your favourite body part.

A popular activity used by art therapists is an emotion wheel, where each segment represents a particular feeling or emotion. Draw a circle below and divide it into the 11 emotions we went through previously, allowing each segment's size to reflect the amount of time you spend feeling these emotions. You can fill in each segment with a drawing that represents that emotion if you'd like to. You might like to try this at the end of a single day, or even over the past week. What would you like your emotion wheel look like, in your ideal world?

Create a drawing that represents your journey to emotional wellbeing. Think about the colours, the movement and any imagery that might come to mind. What does it represent? What does this journey of yours look like?

ARTIST'S TIP

WHEN YOU ARE THINKING ABOUT YOUR JOURNEY TO
WELLBEING, DO YOU IMAGINE IT TAKING PLACE IN A
PARTICULAR SETTING? CLOSE YOUR EYES AND IMAGINE
WHAT YOUR JOURNEY LOOKS LIKE, IF YOU COULD GIVE
IT ANY PHYSICAL DESCRIPTIONS. REMEMBER THAT YOUR
JOURNEY REPRESENTS YOUR EMOTIONS JUST AS MUCH AS
ANYTHING PHYSICAL, SO ITS OKAY IF YOUR CONTINUOUS
LINE DRAWING IS MORE ABSTRACT. THINK ABOUT WHAT
SORT OF FEELINGS YOUR JOURNEY EVOKES FOR YOU.
HOW MIGHT THIS REFLECT YOUR EXPERIENCES?

It can be easy to feel disappointed with yourself if you believe you ought to have done better. But do we really have to be perfect all of the time? On this page, give yourself permission to be imperfect. Think about something you try to be perfect at and create the messiest representation of it that you can!

ARTIST'S TIP

WHEN YOU CAN LOVE YOURSELF FULLY, YOU ALLOW OTHERS TO DO THE SAME AND LIFE FLOWS MORE EASILY.

134

"WHAT DOES NOT ENGAGE
OUR FEELINGS DOES NOT
LONG ENGAGE OUR
THOUGHTS EITHER."

LOU ANDREAS-SALOMÉ

Over this and the next page draw out how you feel over the next couple of days. This might be a nice way to compare and reflect on how you felt on each day. How different and how similar are the drawings?

Studies have shown that getting out and connecting to nature have a positive benefit on our mental health. Go to your favourite outdoor spot and see if you can take an object from this location home with you – perhaps a flower, grass, leaves or pebbles. Spend some time examining your object and connecting with it, reflecting on the positive feelings that special spot holds for you. Then, take a pen and draw the object, trying different colours, line thicknesses and materials to create your continuous line. Are you able to convey the feeling of your favourite outside space?

IN MOMENTS OF STRESS, WHENEVER I HAVE TIME, I TRY TO
TAKE A WALK IN NATURE. I FIND BEING IN A GREEN SPACE
AND UNPLUGGING FROM TECHNOLOGY VERY HEALING. I
ESPECIALLY LOVE THE BEACH; TAKING MY SHOES OFF AND
FEELING THE SAND BETWEEN MY TOES MAKES ME FEEL
CONNECTED TO THE EARTH AND MYSELF.

Think about a person who angers you. Can you draw this anger out using the faces technique? What colours best express your feelings about that person? Include them in your drawing.

"A WORK OF ART WHICH
DID NOT BEGIN IN
EMOTION IS NOT ART."

PAUL CEZANNE

During your therapy journey, you might explore the impact that your childhood has had on the way you live and behave now. Think back to your childhood. Can you remember a time that was particularly happy? Hold on to this memory and draw it out on the opposite page.

My sketch here relates to the drawings I used to do with my mum when I was little.

Anger can be a healthy means of expression, especially when it is directed against the injustices of the world. On a separate piece of paper, draw something that captures your anger about something important to you. When you have finished it, ask yourself what you want to do with it. Tear it up? Cut it into pieces? Burn it? Whatever it is, give yourself permission to do this. Then either stick the fragments here in this book, or make another drawing that reflects how you feel now.

Sometimes we just need to sit with our sadness. The repeat pattern technique can help with this. As the teardrop is a symbol of sadness, slowly fill this page with rows of interconnected teardrops. Go gently; there is no rush. If any memories surface, pause if you need to, but try not to lift your hand from the paper until you have finished.

Surrealist artists such as André Breton and Salvador Dali sometimes used continuous line techniques in a process they called automatic drawing. While focusing on a strong emotion of your choice, let your pen or pencil go for an automatic wander over both of these pages. Then concentrate on separate areas of your doodle and work these into recognizable objects that you spot.

WHEN I FEEL LIKE I HAVE HIT A CREATIVE BLOCK, I TRY
DOING AN ACTIVITY THAT IS INTENTIONALLY MINDLESS;
SOMETHING THAT REQUIRES NO THOUGHT BUT GETS ME
MAKING. WATCHING A VIDEO AND JUST LETTING MY PEN
MOVE ON A PIECE OF PAPER IS A HELPFUL WAY OF LETTING
GO. WHY DON'T YOU TRY THIS WHEN YOU ARE NEXT
FEELING BLOCKED OR STUCK?

Think of something that brings you calm. It could be a walk in nature or listening to your favourite music. How can you make this part of your everyday life? Draw something that symbolizes this for you. If you want, you can carry it with you in your wallet or pocket as a reminder when you next feel stressed and need some calmness.

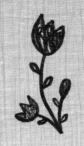

"IF YOUR COMPASSION DOES
NOT INCLUDE YOURSELF,
IT IS INCOMPLETE."

GAUTAMA BUDDHA

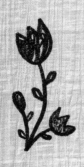

Famous for her giant sculptures of spiders, the artist Louise Bourgeois explained that anger was what made her work. She used it as a response to fear. What makes you angry? And if you were to give that anger a symbol, what would it be? Draw that object on the opposite page.

A good representation of anger for me is a boiling kettle. Anger can fester and be put aside until it reaches boiling point, when it can overflow and explode.

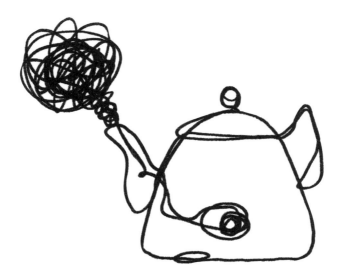

Our anxieties can often appear in our dreams. Do you have a recurring dream or nightmare? Which emotion or symbol dominates this dream and makes it so poignant to you? If you can, link this to your waking life. What other situations have brought out this emotion for you? Draw this out using the repeat motion technique.

Many people who suffer from anxiety also struggle with self-doubt, which can limit their lives in so many ways. This next drawing requires a leap of faith. Pick an object and focus your attention on it for the whole time that you are drawing it. Absolutely no peeking at your moving hand, pen or paper! Only when you are finished can you then look at it. Your drawing may not resemble the object, but it will have its own unique qualities, which are perfect just as they are.

Focus on feelings of calm as you draw an object or a face that you find comforting. Now go back and compare this new drawing to any you have done for feelings of anger. In what ways do they contrast with each other?

"BUT FEELINGS CAN'T
BE IGNORED. NO MATTER
HOW UNJUST OR UNGRATEFUL
THEY SEEM."

ANNE FRANK

Some mindfulness practices suggest viewing distracting thoughts and worries like clouds: the idea is to let them simply drift past us. Today, take yourself outside, look up into the sky and draw what you see. Clouds rarely stay completely still, so let your continuous line drift cloud-like over the page.

Famous for his imaginative landscapes and turbulent skies, J. M. W. Turner once said, "My business is to paint what I see, not what I know is there." Look around you right now – out of the window if you are inside – and, using the objects technique, draw any features that interest you. What attracts your attention? Why might that be?

Art can help us feel less alone in the world, whether we are creating it or looking at it. Research shows that visiting galleries, exhibitions or museums can help to alleviate feelings of loneliness. So go visit a gallery or museum. The work you will see is made by human beings who experienced the same range of emotions as you. When you get home, make a continuous line drawing inspired by one of the artworks that moved you most.

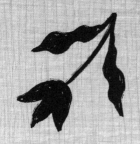

"NEVER GIVE UP, FOR THAT
IS JUST THE PLACE
AND TIME THAT THE
TIDE WILL TURN"

HARRIET BEECHER STOWE

We don't have to feel lonely when we are alone. Quality time alone can be very beneficial, as it creates opportunities for reflection, inner growth and greater mindfulness. The Cornish painter Alfred Wallis consciously chose to shut himself away in his seaside home, where he would paint from memory. Set aside some quiet time this week and dedicate this to drawing from a memory of your own.

Anger can rage through us like a storm, but – like thunder and lightning passing overhead – it will eventually be followed by blue skies. What is the weather like today? Can you draw it here? How does it reflect or influence your own mood?

People are complicated, and our families and friends are often no exception to this. They can be the source of great warmth and connection or the cause of much hurt and isolation. Think about the family you have around you, however large or small. Or, if you prefer, focus on your friends and the people who are important to you. Using the faces technique, can you draw how these individuals make you feel?

Sometimes, it's important to step away mentally to find calm. Where would you go? Think about an imagined place where you might find a feeling of peace. Take your time. When you are ready, return to this book and draw this place. Remember to return here in your mind whenever you are feeling stressed or anxious.

Exercise can be a helpful remedy in times of sadness,
as it boosts our body's natural endorphins. If you don't fancy
doing anything strenuous, there are other forms of exercise
you can do, such as going for a walk, gardening, dancing to
music or jumping about like a kid. Move your body in ways
that make yourself feel more alive; then come back to this
page and draw out this feeling using the shapes technique.

"SOMETIMES THE TIMES
WERE DARK AND THE
OUTLOOK WAS LONESOME,
BUT WHERE THERE IS A
WILL, THERE IS A WAY."

EDMONIA LEWIS

Absence can play just as important a role in our lives as presence. In art, the negative space – the space that surrounds an object – is often an essential aspect of an image as a whole. Optical illusions such Rubin's vase, in which the space surrounding a vase creates the silhouettes of two faces, depend on the concept of negative space. Take a moment now to look back over the drawings that you have made so far, and study the negative spaces in them. How important are those shapes and spaces? Can you do a continuous line drawing that uses these negative spaces?

Today, think about something that you love about yourself.
Perhaps you love a particular feature or aspect of your body,
or maybe it relates to your personality? Keeping this in
your mind, draw out how it makes you feel.

What is your favourite emotion? Can you portray it here, using the faces technique?

Plants and nature are a big part of my life and something
that I try surround myself with. When you are in nature,
you're never really alone. Today, cover this page with plants,
leaves and flowers. Draw a whole garden or forest without
lifting your pen off the paper.

Over the years, people move in and out of our lives for different
lengths of time and reasons, just as we enter and exit theirs.
Try drawing a roadmap of your life, starting from your childhood
until now. Are there many twists and turns, or forking paths?
How steady is the road you are walking on now?

"EVERY DAY IS A JOURNEY,
AND THE JOURNEY ITSELF
IS HOME."

MATSUO BASHO

There are many different types of breathing techniques – a key one we've learned in this book is belly breathing (see page 64).

Put your pen to the paper of these two pages and use the movements of your breath to create lines and movement. Take deep, calm breaths, in and out, as you continue to move your hand over both of these pages.

 ARTIST'S TIP

IN MOMENTS OF STRESS, TRY BRINGING YOUR MIND BACK
TO THE PRESENT. PRACTISING CALMNESS AND BEING PRESENT
IN THE MOMENT ALLOWS US TO FOCUS MORE. IN LIFE WE
MOVE QUICKLY AND OUR MINDS ARE ALWAYS RACING, BUT
PRACTISING BEING IN THE MOMENT HELPS US MOVE TOWARD
A CALMER, MORE FOCUSED WAY OF BEING RATHER THAN
STAYING STRESSED AND ADJUSTED.

This simple exercise can help turn anger into a piece of art. Take a piece of paper and let your anger out by crumpling it up into a small ball. You can even throw it around the room if you like! After a minute or two, when you are ready, unfold the piece of paper and lay it down flat. You will see that the creases have divided the paper into small segments. Fill in those different areas using the repeat motion, repeat pattern, shapes and spirals techniques, varying the pressure of your pencil or pen in each segment. As you draw, feel your anger calming down to a manageable level. After you have finished, stick your drawing onto this page.

The artist M. C. Escher was famous for using negative space and repetitive geometric forms in his artwork to challenge how we view the world. Take a look at his art online (or visit it in person if that happens to be convenient to you!) and then use this space to create your own repetitive pattern. For inspiration, think about something in your life that didn't turn out the way you expected.

Fill this page with spirals. When you have finished drawing, pause for a moment. Then return to your drawing and, using the repeated pattern technique, turn each of those spirals into flowers by adding petals to them. It's interesting how easy it can be to turn one thing into something else completely, with a little imagination.

"SIMPLICITY IS THE GREATEST
ADORNMENT OF ART."

ALBRECHT DURER

We can sometimes get caught up in perfection and worrying about things "should be", rather than accepting them as they are. We've tried drawing with our non-dominant hand already on page 112 in order to key into our unconscious mind. Now I want you to try using your non-dominant hand again as a way to loosen up and have fun. Use these two pages to focus on an object in the room and draw it with your non-dominant hand - you might even like to put on some music to get you in the mood!

The Zen Buddhist master Thich Nhat Hanh was well-known
for creating beautiful works of calligraphy. Some included
the Zen sacred symbol for enlightenment, the ensō circle –
a circle created with one singular brushstroke. A circle can be
one of the hardest shapes to draw freehand, and as a single line
allows for no changes, this practice symbolizes letting go of
the mind and allowing the body to create. Using a thick pen or
brush, take a few deep belly breaths (see page 64) and enjoy a
moment of calm. When you are ready, place your pen or brush
on the paper and then float your hand round to make the
shape of a circle. I've given you some space for this prompt
so you can try this a few times.

REMEMBER TO TAKE TIME FOR YOURSELF TODAY, IT COULD
BE A WHOLE DAY OR EVEN JUST FIVE MINUTES. TAKE A STEP
OUT OF YOUR DAY AND FOCUS ON YOUR BREATH,

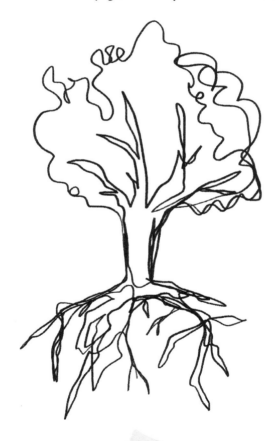

Trees represent physical and spiritual nourishment. They are rooted in the earth and give us so much. Go for a walk and take a photo of a tree or plant that stands out to you or that attracts you in some way. Then draw your version of it on the opposite page without lifting your hand from the page, in the way that I have done below.

With time, our sadness may come to have a gentle beauty
of its own, as we look back through the prism of loss to happier
times. Healing memories may begin to emerge out of the darkness.
The next drawing reflects that process. Cover the space below with
a layer of soft charcoal, rubbing it with your hand to spread it
around. Then take the sharp edge of an eraser and draw an object
or face that represents a happy memory for you, digging this out
of the grey in continuous lines.

"ORIGINALITY CONSISTS
NOT IN A NEW MANNER
BUT IN A NEW VISION."

EDITH WHARTON

Mandalas originated in the 4th century and were created in countries such as Nepal, India, China and Japan. In Buddhism, they symbolize the universe in its ideal form and are used in meditative practices. Using shapes and repeat patterns, can you draw a mandala that represents a state of calm on the opposite page? As you work on it, allow the process to fill you with a sense of peace.

Here is an example of a mandala I drew.

Fulfilling relationships can be a wonderful source of happiness. What does love look like to you? Think of someone you love deeply, whether romantically or platonically. Can you draw this love? How would it look on paper?

"CREATIVITY IS NOT
THE FINDING OF A THING,
BUT THE MAKING SOMETHING
OUT OF IT AFTER IT IS FOUND"

JAMES RUSSELL LOWELL

Landscapes can remind us of places that we love, places can bring us nostalgia and bring us positive and negative memories. Is there somewhere you can think of that brings you joy? Can you draw it on the page opposite, using the continuous line techniques, in the way that I have done here?

OVER TO YOU

MAKING SPACE FOR YOU

Now that you have the tools you need and you are familiar with continuous line drawing, you can put it all into practice. I have deliberately left this part of the book blank, as I want to give you space to explore the drawing techniques in your own way without me telling you what to do!

That said, if you wish, you can use the following pages as a daily drawing journal in which to create a continuous line drawing each day. This might be a nice way to reflect on the week you've had and see how the drawings compare to each other day by day. However, there is no pressure – use this space for you however you like, in moments of anger, happiness or even stress. This is the space to just draw!

CONCLUSION

Congratulations for getting to the end of this book. It might have been a difficult experience for you, especially with those harder emotions, but you should be proud that you gave yourself permission to feel them and then draw them. However, if you haven't been able or willing to work through all the emotions just yet, please know that's okay too. Emotions take time to process and you can always come back to this book whenever you need to.

I hope *The Intuitive Drawing Journal* has given you a number of ideas that you can use in the future to help you continue to process your emotions and explore your feelings through creativity and continuous line drawing. The work shouldn't just stop here!

These techniques really are tools for life, as my own story goes to show. I mentioned at the start of this book how I wasn't sure I was meant to be in university. My journey through education ended up being difficult for many reasons. I felt at times like I wasn't really supported or being told that I was doing "a good job", which is so important when it comes to a young person's confidence – especially in art. While I often felt like this was due to my intelligence, I now realize that I was being let down by a failing education system, as so many other people are. I mention this now, as creating this book represents a monumental achievement for me. Given my past experiences, I am so proud of myself for creating something that will hopefully help others. I particularly want to mention this to anyone who is currently struggling in school or in any form of learning, as I truly believe you will get to where you want to be if you keep on persevering, processing your emotions and moving forward. You too will find your own way.

ACKNOWLEDGEMENTS

First, I would like to say thank you to my family – my mum, dad and sister. I am so grateful for you all and I feel lucky to have you all as my family. I would also like to say thanks to my Aunt Julia, Liz and my grandma. I am so lucky to have so many strong women in my life that have helped me become the woman that I am today.

I'd like to say a special thanks to my wonderful mum. You have always had my back and supported me through may difficult times. Through the hardship you have experienced, you have made it easier for me to make a career as an artist and I am eternally grateful for this. You have provided me with so many opportunities as well as the space to be creative physically and mentally. You have helped me become a strong, empathetic, kind and independent person I am today. You are a beautiful soul.

Kyle, my lovely partner. You have seen me at my best and worst. You have always supported me and cheered me on throughout the many years I've known you. We have grown together and learned a lot from each other. Thank you for always giving me space to feel and to be heard. You nourish my inner child and I appreciate all the laughs and silly moments we have had together. I love you.

Finally, I would like to thank my therapist, Liz. I am so thankful that I was introduced to you four years ago. You have supported and nourished me countless times over the years. Thank you for providing space for me to feel vulnerable and to be honest without feeling judgment. Through knowing you I have healed a lot within myself and I treasure the relationship we have built, as well as the person you have helped me become.

RESOURCES

First and foremost, I would like to emphasize the importance of getting therapy when you need it. Counselling is such a useful tool when done correctly, and can honestly change your life. However, I understand that good counselling isn't always accessible, so it is important to find other people who can support you. Here are some additional sources of support to help get you started.

Organizations

The British Association of Art Therapists: www.baat.org
Helplines Partnership: www.helplines.org
Mind: www.mind.org.uk
Samaritans : www.samaritans.org
Self Help UK: www.selfhelp.org.uk
Self Space: www.theselfspace.com
American Art Therapy Association: www.arttherapy.org/
Psychology Today: www.psychologytoday.com
Therapy Route: www.therapyroute.com/therapists/united-states
The Australian and New Zealand Arts Therapy Association (ANZATA): www.anzacata.org/FIND-A-THERAPIST
Psychology and Counselling Federation of Australia (PACA): www.pacfa.org.au/Portal/Find-a-Therapist/Find-a-Therapist.aspx
Journal smarter: www.journalsmarter.com/lab

Books

Counselling for Toads by Robert de Board (Routledge, 1998)
The Mandala Way by Eitan Kedmy (Watkins, 2023)
Clarity and Connection by Yung Pubelo (Andrews McMeel, 2021)
Shodo by Rie Takeda (Watkins, 2022)

WATKINS
1893

The story of Watkins began in 1893, when scholar of esotericism John Watkins founded our bookshop, inspired by the lament of his friend and teacher Madame Blavatsky that there was nowhere in London to buy books on mysticism, occultism or metaphysics. That moment marked the birth of Watkins, soon to become the publisher of many of the leading lights of spiritual literature, including Carl Jung, Rudolf Steiner, Alice Bailey and Chögyam Trungpa.

Today, the passion at Watkins Publishing for vigorous questioning is still resolute. Our stimulating and groundbreaking list ranges from ancient traditions and complementary medicine to the latest ideas about personal development, holistic wellbeing and consciousness exploration. We remain at the cutting edge, committed to publishing books that change lives.

DISCOVER MORE AT:

www.watkinspublishing.com

Read our blog

Watch and listen to
our authors in action

Sign up to
our mailing list

We celebrate conscious, passionate, wise and happy living.
Be part of that community by visiting

 /watkinspublishing @watkinswisdom
 /watkinsbooks @watkinswisdom